The Artist's Eve

LEARNING TO SEE

If you've ever wanted to learn
to draw, or to draw better,
the Learning to See series offers
a mix of inspiration, encouragement,
and easy-to-complete exercises
that will have you filling the
pages of your sketchbook more
confidently in short order.

The Artist's Eye

Peter Jenny

Princeton Architectural Press · New York

For Rahel

Princeton Architectural Press
37 East 7th Street, New York, NY 10003

Visit our website at www.papress.com

Originally published by Verlag Hermann
Schmidt Mainz under the title *Zeichnen
im Kopf* © 2004 Professor Peter Jenny,
ETH Zurich and Verlag Hermann
Schmidt Mainz

English edition
© 2012 Princeton Architectural Press
All rights reserved
Printed and bound in China
15 14 13 4 3

Editor: Nicola Bednarek Brower
Translation: Benjamin Smith
Cover design: Deb Wood
Typesetting: Paul Wagner

Special thanks to:
Bree Anne Apperley, Sara Bader,
Janet Behning, Fannie Bushin, Carina
Cha, Russell Fernandez, Jan Haux, Diane
Levinson, Linda Lee, Jennifer Lippert,
Gina Morrow, John Myers, Katharine
Myers, Margaret Rogalski, Dan Simon,
Andrew Stepanian, and Joseph Weston
of Princeton Architectural Press
—Kevin C. Lippert, publisher

Image credits:
Exercise 6: Image taken from Ridpath,
 Ian. *Die großen Sternbilder: 88
 Konstellationen und ihre Geschichten.*
 Düsseldorf: Patmos, 2004.
Exercise 9: Leonardo da Vinci, *Head of
 Bearded Man (self portrait)*, 1510–1515
Exercise 18: Inspired by Giuseppe
 Arcimboldo
Exercise 20: Image taken from
 Rickenbach, Judith. *Nasca—
 Geheimnisvolle Zeichen im alten Peru.*
 Zurich: Museum Rietberg, 1999.

Library of Congress
Cataloging-in-Publication Data
Jenny, Peter, 1942–
[Zeichnen im Kopf. English]
The artist's eye / Peter Jenny. — 1st ed.
215 p. : ill. (some col.) ; 15 cm. — (Learning
to see)
Originally published: Zeichnen im Kopf.
Zurich : ETH ; Mainz : Verlag
Hermann Schmidt, 2004.
ISBN 978-1-61689-056-8 (alk. paper)
1. Art—Technique. 2. Art—Problems,
exercises, etc. I. Title.
N7430.J4613 2012
702.8—dc23

 2011040021

Preface

Your mind is the studio; your eyes are the light. Even amateur artists, without formal training, can use their imagination to create. The eye not only loves order but also seeks out form in random patterns. This little book aims to open your eyes to the incidental, to the suggestions of images in everyday objects, to the beauty in the ordinary, such as blotches, clouds, scratches, etc. Your eyes will encounter images that you previously overlooked. Some chapters encourage you to draw, paint, or photograph. But you can also choose to use this book as a basis for observation and think up images as

you see fit. You will be a creator of images. Imagination—something no one can prescribe— then simply means opening your eyes and discovering. It's that simple.

Peter Jenny

Introduction

Blindman's buff

Games and amusement are a part of life.
The lightness and frivolity of recreation allow
us to relax, creating a sense of safety that
encourages us to experiment and take risks,
even without any guarantee of success.
Playfulness is a reward in itself.

A successful restaurant in Zurich,
Switzerland, that goes by the name of Blinde
Kuh (the German phrase for "blindman's buff"),
takes its cue from the eponymous children's
game. Its waiters and waitresses are blind
or partially sighted, and there is no light in the

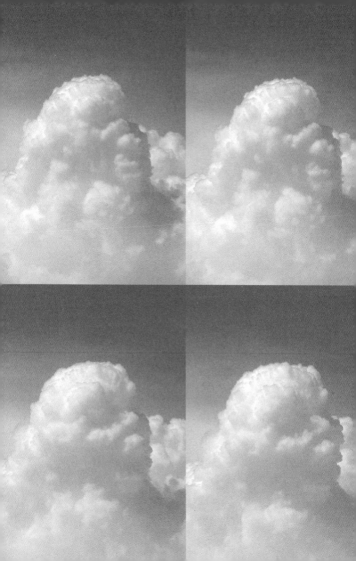

restaurant, leaving the guests in total darkness. Without visual cues they can focus on their senses of taste and smell; in fact, the lack of light heightens their appreciation of what is on their plates and in their glasses. The absence of sight thus enhances the gustatory experience. This anecdote demonstrates that it is possible to see with our minds and that what is missing can make our desire grow.

Imagination

All of us know the feeling of suddenly seeing recognizable images in mere fragments, nebulous shapes, or random marks. These discoveries depend on having an open mind—whether in seeing, thinking, or remembering. Fortune-tellers are thought to have the ability to see into the future—a gift that few of us have. When it comes to seeing images, the opposite is the case—most of us can translate a vague visual collection into something identifiable. The eye and the mind work together to paint, draw, and create through

imagination alone. The word *work*, however, doesn't appropriately describe this creative act, as this accomplishment doesn't involve effort and pain. The goal of this book is to inspire you to discover signs and visual cues and to expand upon them—a process of transformation that leads to something surprising. Who would want to miss the chance to uncover something mysterious?

Perception

Our personal way of thinking influences what we see in our surroundings, visually transforming and reshaping mere allusions according to our own brand of curiosity. This process is similar to cooking with only a few miscellaneous ingredients that happen to be at hand and ending up with something surprisingly unique and delicious. In the context of our activity here, a few seeds of an idea can grow in our minds into a complete image. (If we are very hungry, the images will likely be of food.) Ideas often

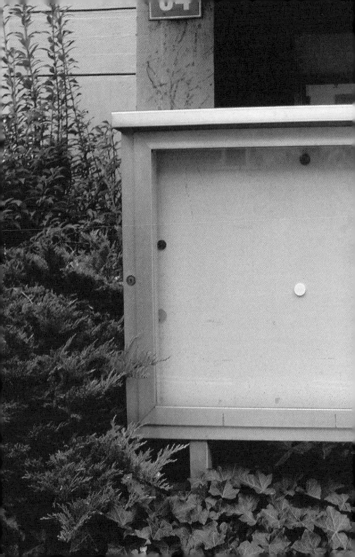

reflect our desires—they are not random but already exist in the subconscious.

It is important to have a certain sense of abandon when trying to discover images and to enjoy the fruits of success when it happens. The concurrence of recognition and enjoyment applies equally to amateurs and professionals; they all succeed in seeing more in a blotch, cloud, or fragment than there actually is. Beyond this relationship between recognition and enjoyment is yet another partnership: remembering and imagining. Thinking back (remembering) and thinking ahead (imagining) at the same time seems to be contradictory; in reality, it is the prerequisite to being a visionary.

The ambiguous sense

Any forms, colors, and textures that activate our visual thinking can create meaning precisely because of their ambiguity. They can be the sources of ideas and complex images as long as we allow them to be so. It is wonderful to be able

to see whatever we like, to discover something new in that which is familiar—all facilitated by associative thinking.

Children (and adults too, of course) often concoct stories without sharing them with others or writing them down. English teachers want to see essays written down in black and white, following the rules of grammar and spelling, which directly conflicts with the freedom inherent in the act of thinking. The same is true for art teachers: the classroom guidelines of the studio are equally stifling, only the medium is different. Outside of school the rules are more easily bent. Everyone has the freedom to use their imagination in whatever way they choose.

Artists often push the limits of the freedom of thought and are, as a result, sometimes thought to be insane. Navigating the limitless possibilities that come with freedom is difficult. Perhaps that is why artists are considered special, because nonartists are never sure what drives them and what provokes them. (Mistrust is not

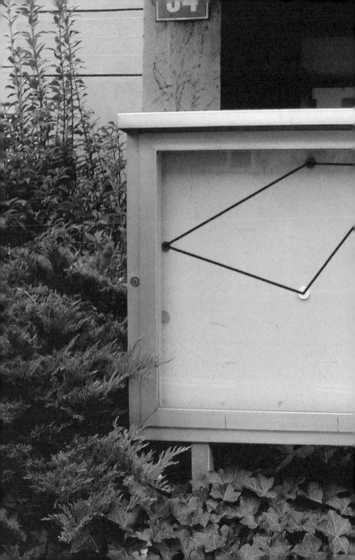

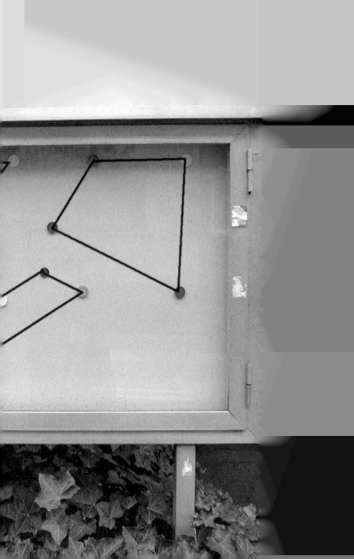

sufficient, though; one must also be able to speak about visual thinking.) Freedom held by the reader of a book and the viewer of an image is not just about comprehending words and pictures, it is also about being able to personally and subjectively interpret what is in front of the viewer.

Interdisciplinary perception

Can a single person's insights matter to others, or are they completely unique to him or her? Is freedom limited to pastime activities, such as participating in an arts and crafts group? We all want to be able to do as we wish, to create whatever and however we want. There is, however, considerably less agreement as to how best to achieve this. Many schools emphasize traditional academic disciplines, such as math, science, and literature, with art a mere elective subject. In the arts the distinction between right and wrong is grayer than in the sciences. If art differs from the other courses of study, this is for two reasons.

First, honing our senses of perception through art is fun; and second, this game isn't a recognized adult activity (at most, it's a means to an end). Our goal here is to learn about visual thinking, and the game lies in the path to that goal. The exercises (the game) and the perception (of images) together can inspire even nonartists to participate. Some instruction to this end—on being inspired by forms, colors, and surfaces—will hopefully help.

As is so often the case, we can learn a lesson from children. Even a child, by using his or her imagination, can transform an idea into something concrete—an intermeshing of fiction and reality. For example, if given a figure formed out of a horse chestnut and matches—without prompting, without effort, and through imagination alone—the child can form a picture of a character that can grow into stories. The level of simplicity or complexity has nothing to do with age. The literary scholar Peter von Matt writes, "The difference between what we consider

appropriate for children and what children actually like is very difficult to discern. This is essential to remember for anyone attempting to nurture the imagination, the totally different form that fantasy takes in the minds of children."

Age differences

It sounds reasonable to protect children from age-inappropriate material. For adults to learn from the untamed instincts of children seems improper and counterintuitive, but it is worth the effort. (In another book I propose "fake children's drawings" as a learning exercise. The drawings may look childish, but they are not childish at all. The goal is to give readers courage and to convince them that they too can draw.)

A gap between the ages remains that can be bridged with associations at best. My interest is in accessing the intuition that (perhaps) we already had at infancy, before any schooling. We must simply learn to value and use this knowledge. Not unlike ducks, who can swim minutes

after being born, children are born with instincts, and among them is the ability to recognize images. Children in their toddler years are walking, talking fountains of questions, bombarding the adults in their lives with their inquisitiveness. A child's curiosity, awkwardness, experimentation, mimicry, and unbiased attitude are all characteristic of the abundance of his or her imagination. Adults are quick to belittle such childish behaviors, but one thing is for certain: children ask more questions about the world, while adults tend to make declarations.

New ideas, however, are not just within the purview of children and creative individuals. They are also—and you may need to revise your prejudices here—often conceived of by older people. The elderly are overwhelmingly underestimated in our society, even though they possess one of the most important requirements for creating: time. Watch a grandfather or a grandmother with his or her grandchildren, and you'll see how infectious imagination can be.

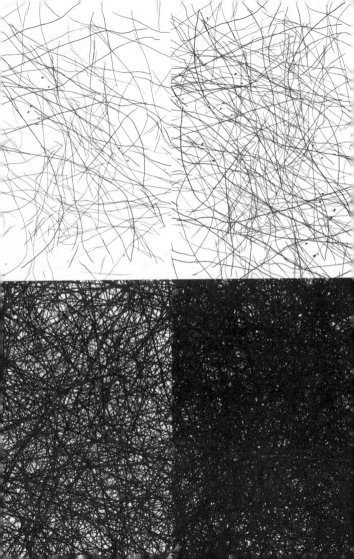

During childhood adults often tell children not to worry, that they have a lot of time to learn everything. Small children, adolescents, and adults each see the world differently with a different level of authority. In old age that authority often becomes tentative and restrained.

Thirst for ideas

Everyone craves new inspiration. As soon as you think up an image, the desire for the next one surfaces automatically and follows almost immediately. The British actor and author Peter Ustinov must have been convinced of the value of images, because he used every spare moment to draw. The binding force for his varied activities (actor, writer, ambassador for Unicef, playwright) was his ability to think in images. I believe that visual thinking can be beneficial during our daily activities and during the entirety of our lives— just as art is.

You can use the skills of an artist even if you choose a noncreative professional path,

like being a teacher, architect, shoemaker, or doctor. In art subjectivity plays a large role; you can achieve a certain objectivity only by taking into account various kinds of interpretation. Were a teacher to demand "absolute objectivity," he would be on the wrong path. I completely understand why we always want to draw a line between right and wrong. I suspect that it has to do with the insecurity brought on by the increasing complexity of modern society, which makes us want to avoid ambiguity, even in art. However, the fields of images that we plant, till, and plough are our own personal piece of culture, binding us all together. Images do not originate as meaningless fragments. When we uncover them, they are ready to thrive, needing only our attention to proliferate. And then you will realize that there's something new that you came up with. In other words, the spirit goes where it wants to. But even made-up images come only to those who are ready to see them.

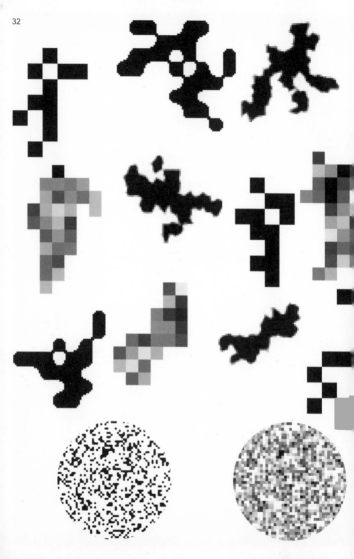

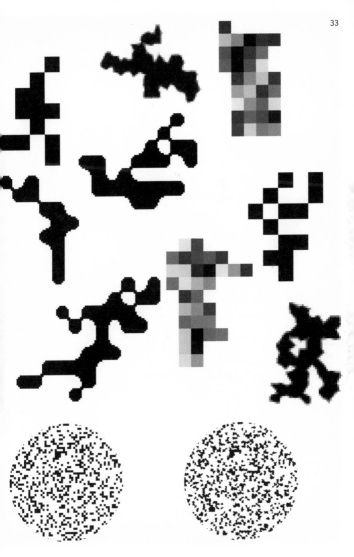

This book is concerned with images that don't have a readily identifiable form and are therefore open for interpretation. Different minds perceive shapes distinctly, resulting in a wide range of possibilities. The culture of seeing is not a closed practice; it is not confined by walls like a museum. Perception takes place in our minds, which is like a playground where various views meet and stimulate one another. We build images in our minds out of traces, hints, and fragments. When multiple viewers all see the same thing in a set of marks, it leaves nothing to the imagination. But when different viewers can interpret the fragments in a number of different ways, then the imagination can embark on the most inspiring and unexpected of journeys.

1

Rubbing

Everyone knows how to make a rubbing—even children can use the technique to copy an image of a coin through a thin piece of paper. Take a solid surface with a texture, put a piece of paper on top and rub over it with a pencil, and the picture is done.

Expanding your field of vision
You can use much more than coins to explore this technique. Any solid surface with the slightest bit of texture is suitable. Light and shadow (negative and positive) reveal themselves.

2

Crinkling

You can easily create topography with nothing more than a piece of paper. The crinkled paper can suggest a landscape or something else, depending on the lighting and the point of observation.

Expanding your field of vision

Crumple up a piece of paper (try various types of paper) and examine how light affects the papers differently. The interplay between light and shadow can be intensified by coloring certain areas.

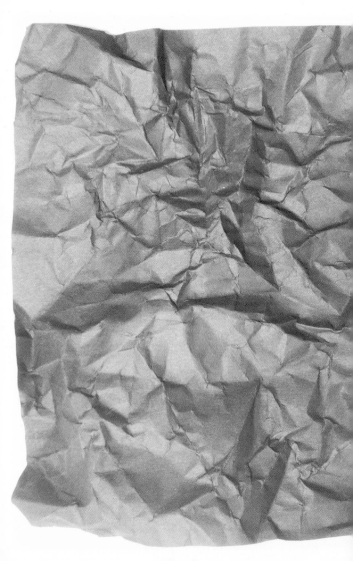

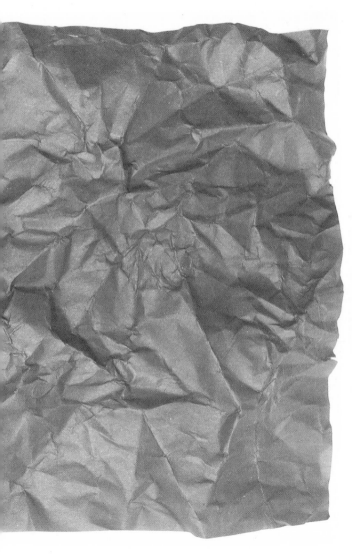

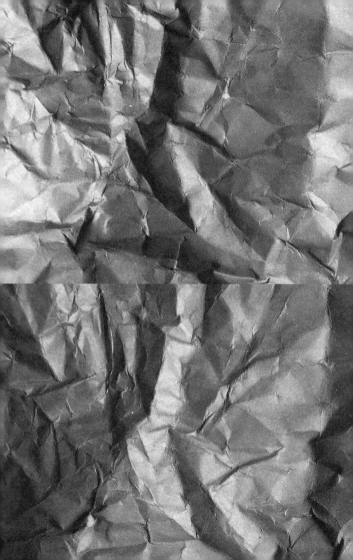

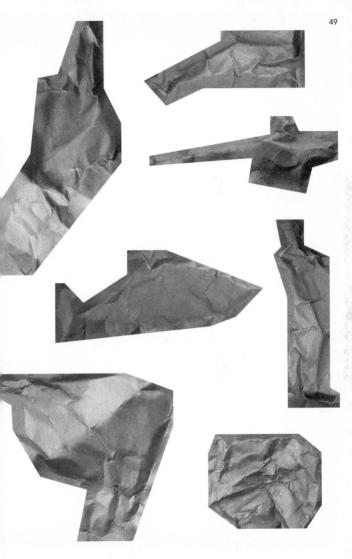

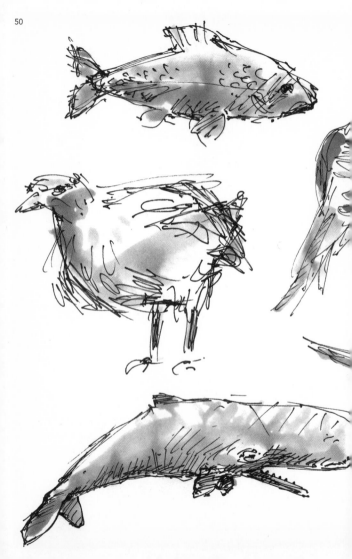

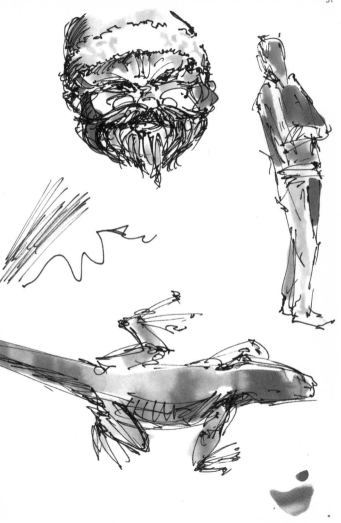

3

Outlining

The very shape of a piece of paper can affect the content of a drawing. The relationship between the image and the edge of the paper influences what we see.

Expanding your field of vision
Abandon the logic of straight lines. Rip a piece of paper into different shapes without any regard for form.

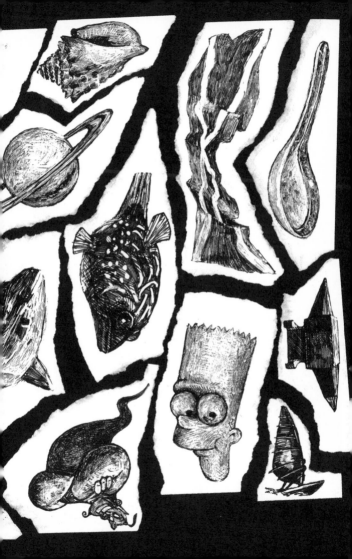

4

Splattering

The appearances of vague shapes aren't always deceptive—often their ambiguity disguises a specific form. Splatters of paint randomly placed on a piece of paper don't just conjure up the work of Jackson Pollock but also of tentative images waiting to be found.

Expanding your field of vision
Slop, spray, splatter, and dribble ink onto white paper. Let some spots dry on their own; blot others dry with a tissue.

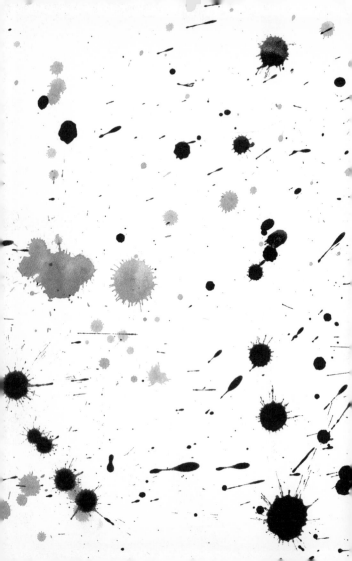

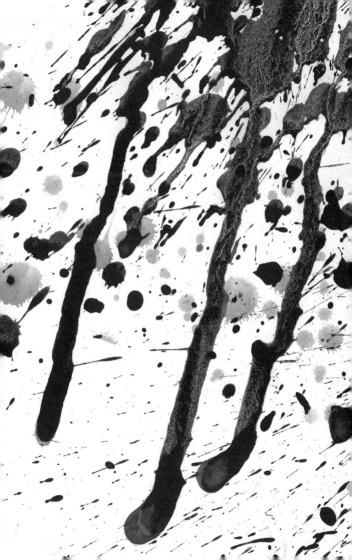

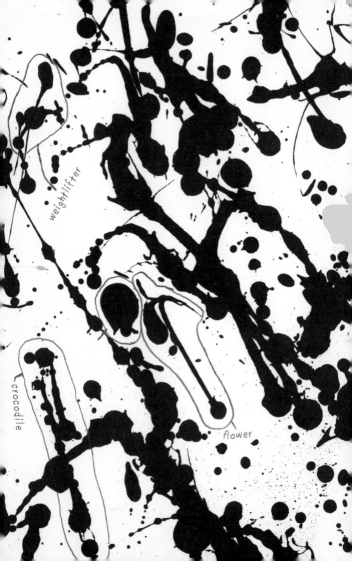

weightlifter

crocodile

flower

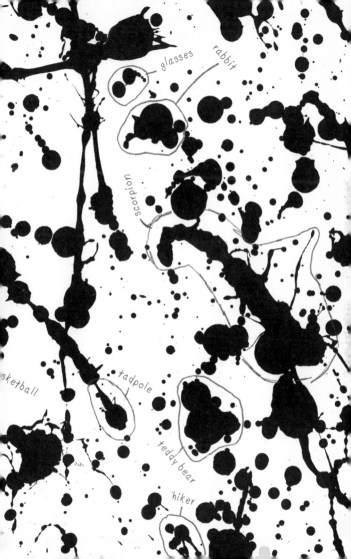

5

Marbling

Non-water-soluble paints that are lighter than water can float on the surface of water. The formal characteristics of these floating images vary depending on the material. Colors can be applied with intention (in contrast to exercise 4).

Expanding your field of vision

Dribble resin or enamel paint into a basin of water. Move areas of paint around like little rafts that constantly change their shape. Place a piece of paper on the surface to lift off the colors.

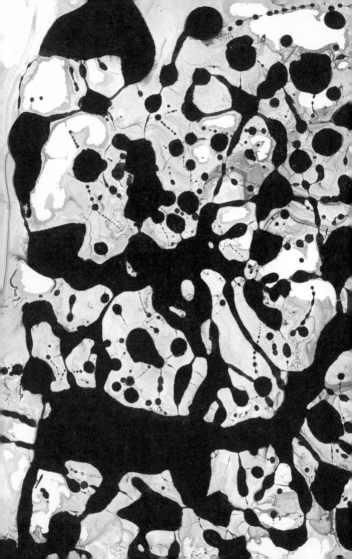

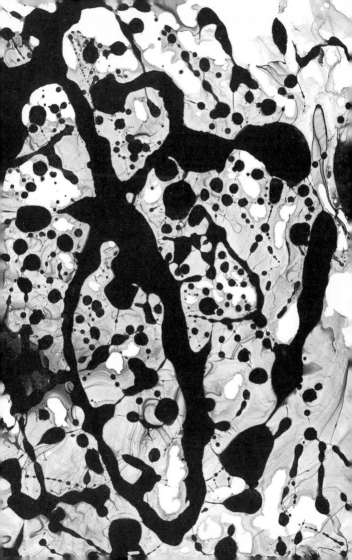

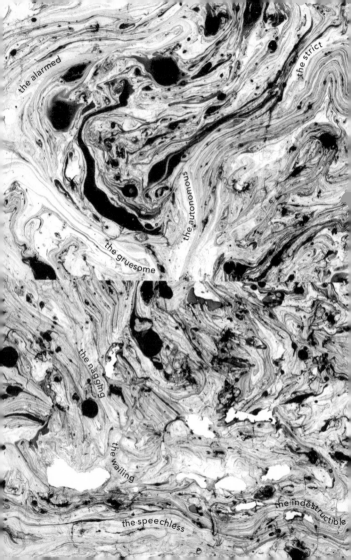

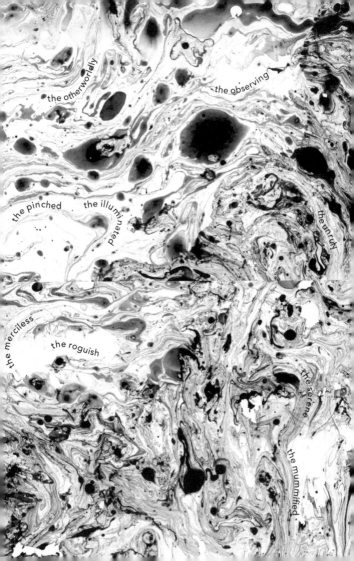

the otherworldly

the observing

the pinched

the illuminated

the unruly

the merciless

the roguish

the serene

the mummified

6

Mirroring

The familiar, reversed image of ourselves that we see during a casual glance in the mirror shapes our self-perception. The use of a mirror to double parts of an image brings about surprising views.

Expanding your field of vision
Take a rectangular mirror, place it perpendicularly on the following double-page spread, and move it over the surface until you find a mirror-image figure you want to draw. You can do this exercise with any image.

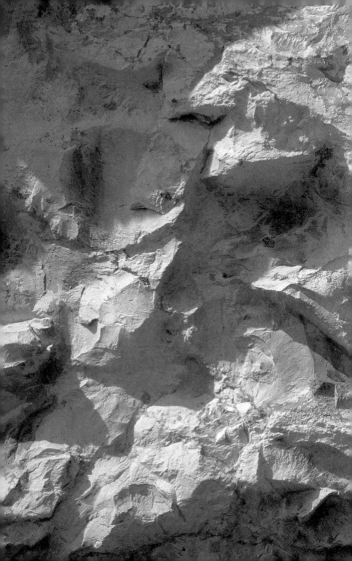

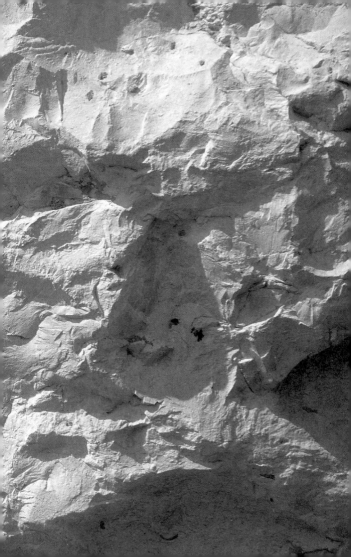

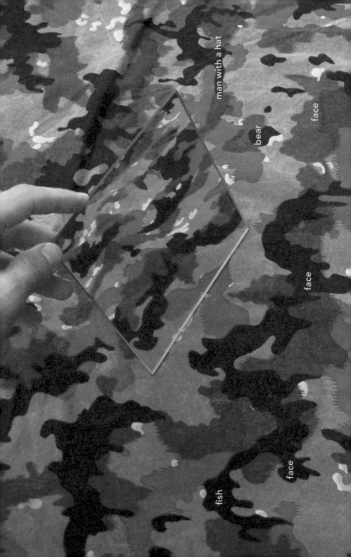

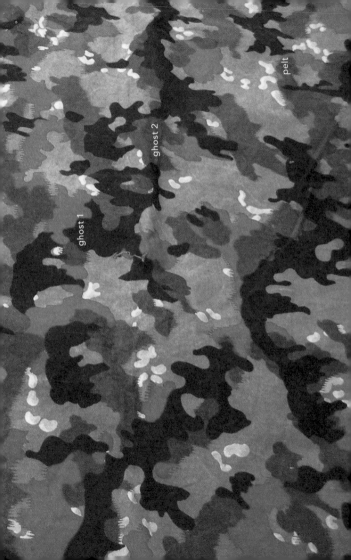

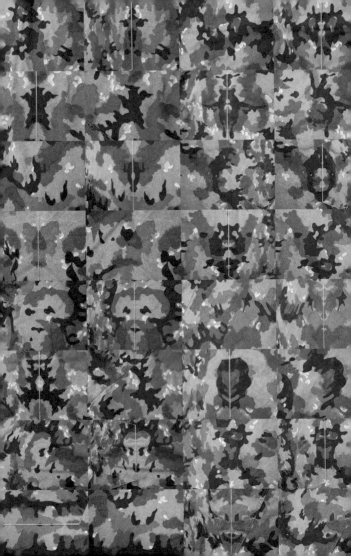

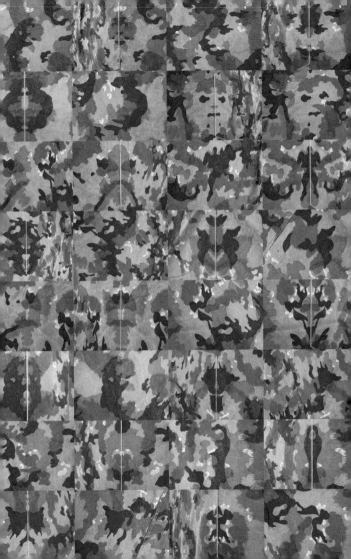

7

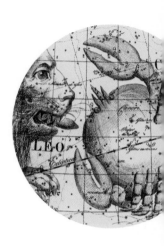

Constellations

Since the beginning of time, stargazing revealed images shaped by myths, desires, conventions, and orientation points.

Expanding your field of vision
Looking at the night's sky can give you orientation points from which to uncover an image. If the stars are not visible, then create your own sky: with a piece of black paper and some Wite-Out, your own sky is within reach.

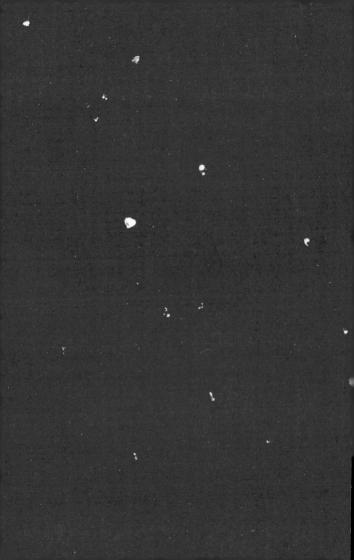

Andromeda Air Pump Bird of Paradise

Charioteer Chisel Giraffe

Little Dog Capricorn Carina

Compass Dove Berenice's Hair

Goblet Cross Swan Dolphin

Crane Hercules Clock Hydra

Hare Libra Wolf Lynx Lyre

Serpent Bearer Orion Peacock Perseus

Southern Fish Stern Pyxis

Sculptor Shield Serpent

Toucan Big Dipper Little Dipper

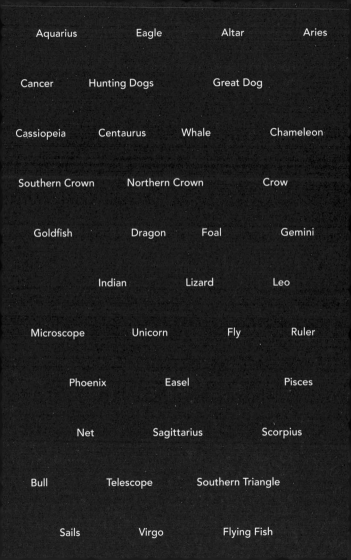

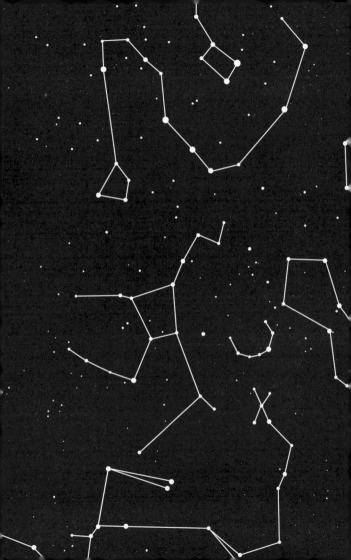

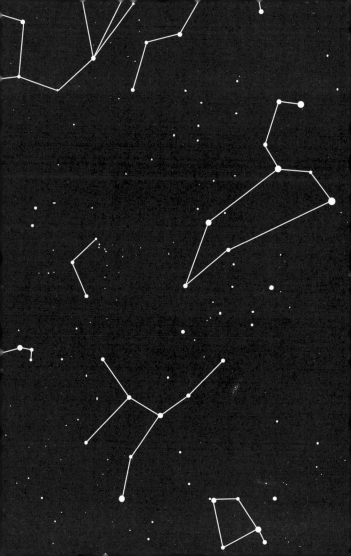

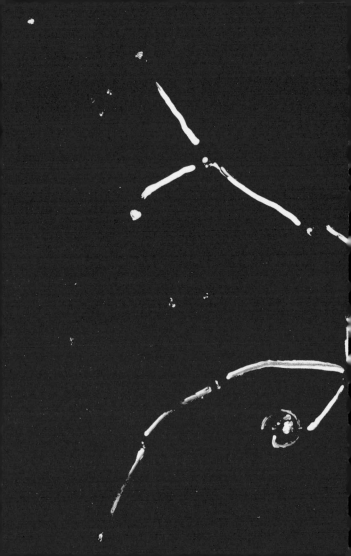

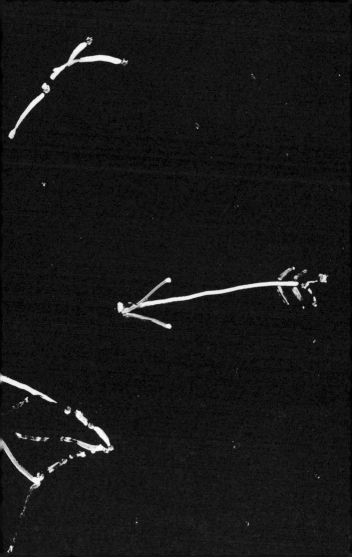

8

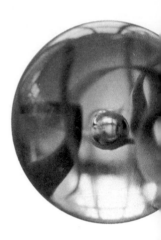

Cloud pictures

It's not at all absurd to observe weather patterns as inspiration for a series of images. We all associate the blue sky and warm light with vacation, free time, and other times of relaxation, but perfect weather can often be a boring subject.

Expanding your field of vision

Take photographs of or find a variety of cloud images. Simply glancing skyward can help you find pictorial subjects.

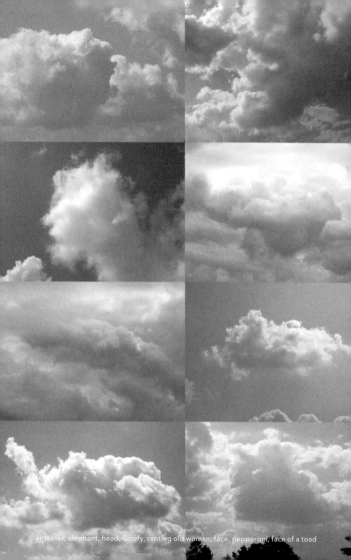

anteater, elephant, head, Goofy, ranting old woman, face, pepperoni, face of a toad

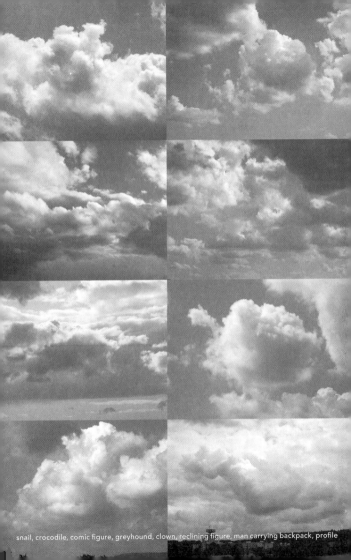

snail, crocodile, comic figure, greyhound, clown, reclining figure, man carrying backpack, profile

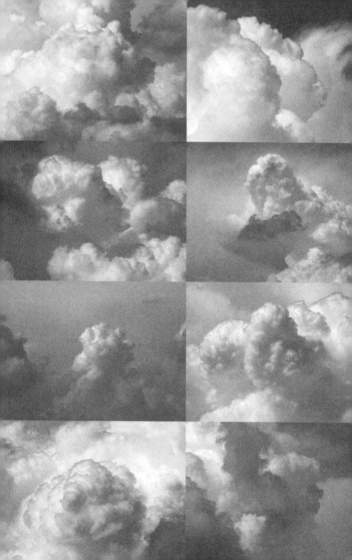

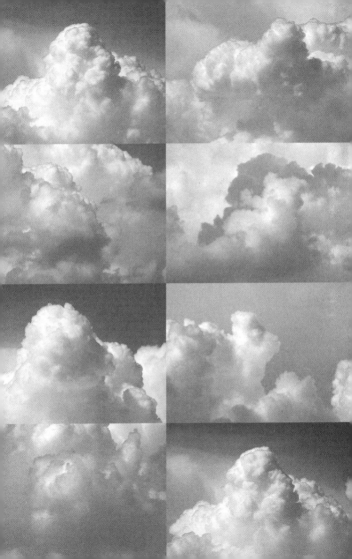

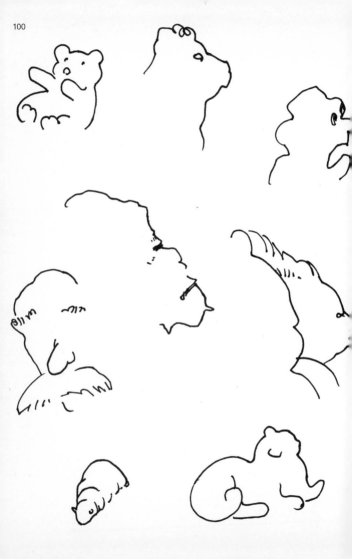

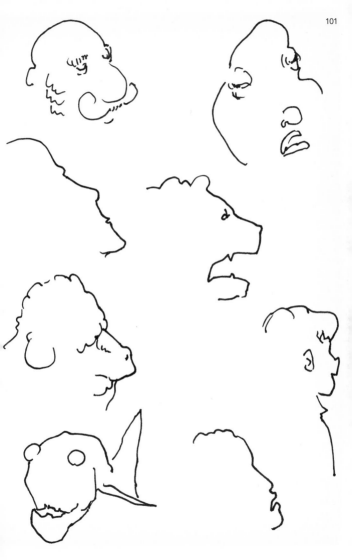

9

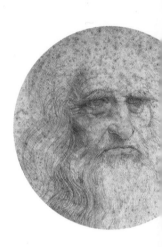

Spots on the wall

An aged, weathered wall can suggest images that you can use as a subject of your drawings. Leonardo da Vinci once said that spots on a wall represented a fount of images for him.

Expanding your field of vision
Photograph a number of different weathered walls. Compare the spots and blotches on the photographs to see differences and resemblances. A collection of photographs of these spots could itself be a picture book with various possible interpretations.

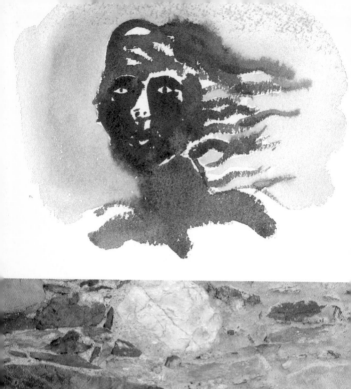

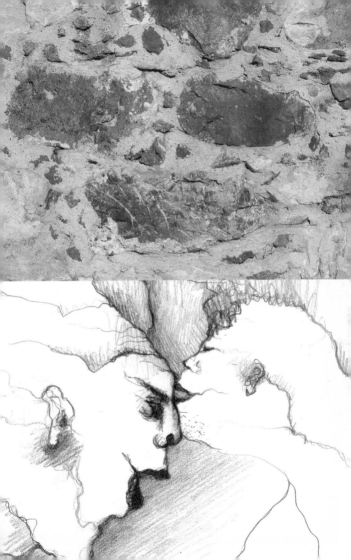

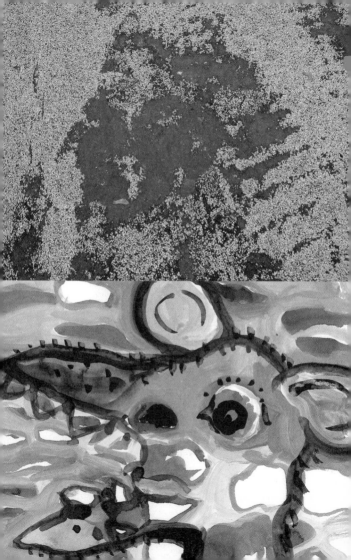

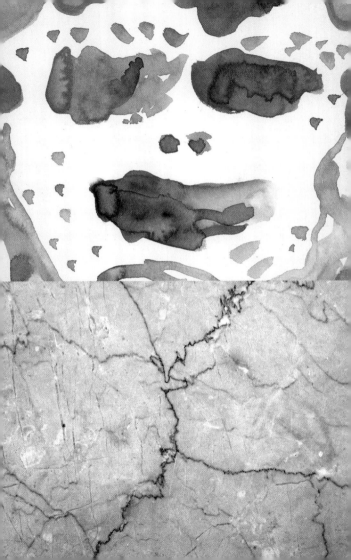

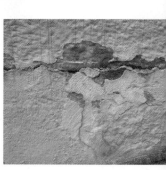

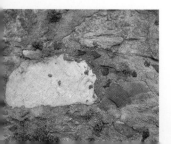

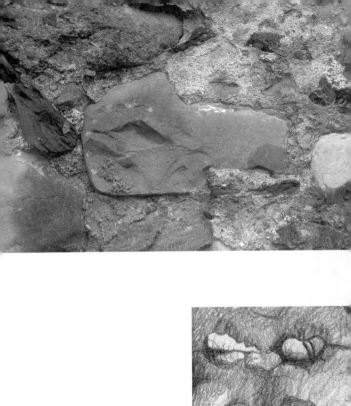

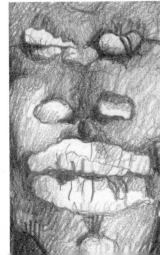

10

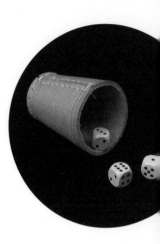

Game

The red, green, and yellow thumbtacks in this exercise are different from one another and form, according to each color, fixed points for shared interactions. The playful and quick succession allows for the creation of random groupings in which you can discover images.

Expanding your field of vision
Place a handful of colored objects into a cup and pour them out onto a sheet of paper. You are not limited to thumbtacks—buttons, M&Ms, colored balls, and confetti are just as good.

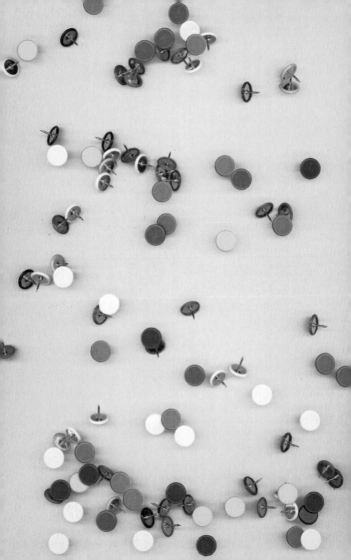

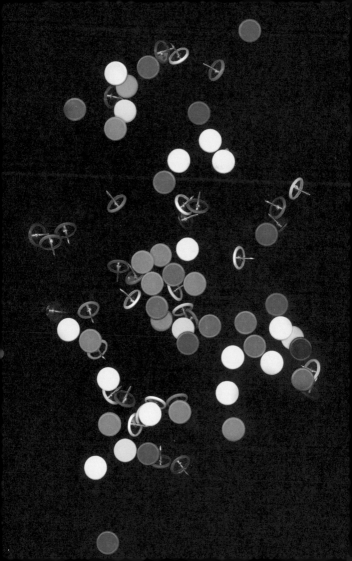

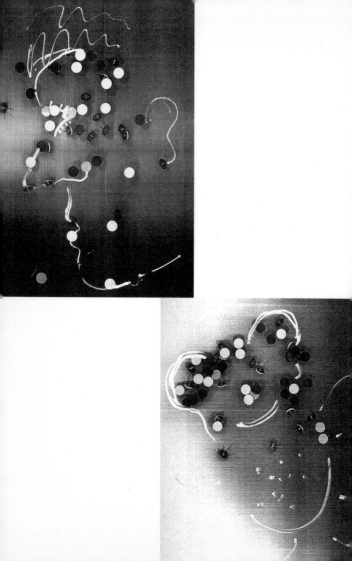

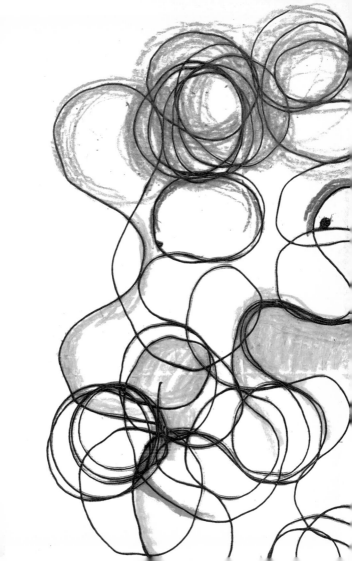

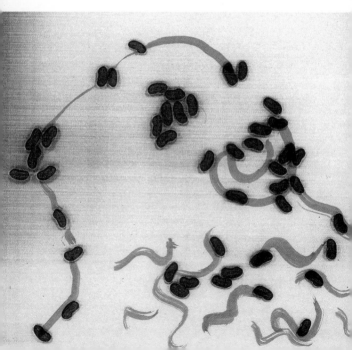

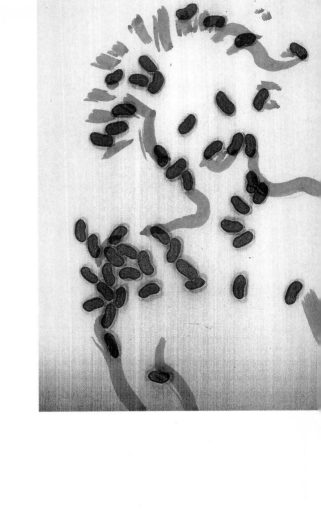

11

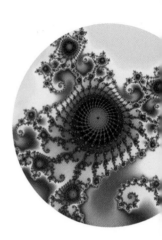

Chaos

If you have made it this far in the book, you will
be able to see how the exercises in it relate
to each other and how wide the range of forms
is that we can perceive with our senses. The
allure of the hidden propels our will to discover.
Disguising and uncovering are not exclusive
but depend on each other.

Expanding your field of vision
Most of us take photographs casually, without
much premeditated thought. By choosing
atypical subjects, we can tell our stories—
whether old or new—in a fresh and unexpected
manner.

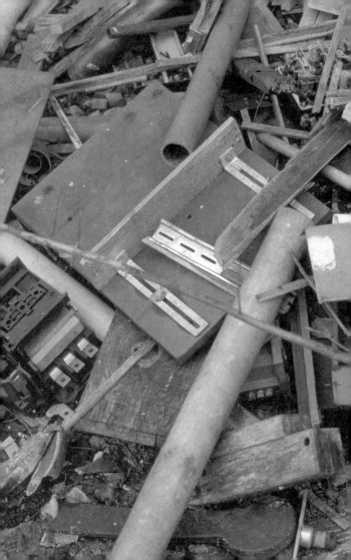

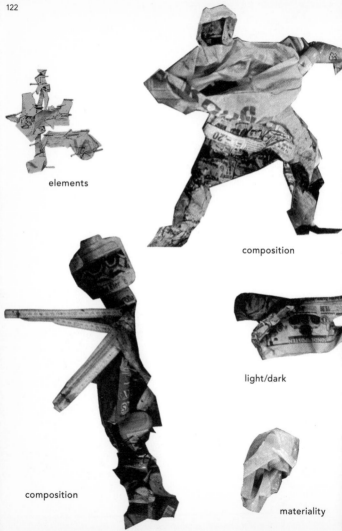

elements

composition

light/dark

composition

materiality

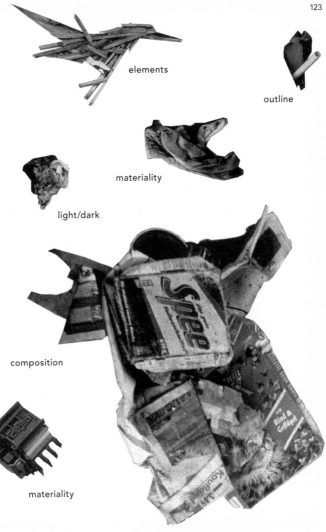

elements

outline

materiality

light/dark

composition

materiality

12

Doodling

It's always an adventure to take a stroll
through an unfamiliar city. Doodling is a similar
experience: the piece of paper is the city;
as the pencil winds its way around the city,
its streets and paths slowly take shape.

Expanding your field of vision
At first glance doodling always appears to
be random scribbling. But when you look closer,
you can begin to make discoveries. From the
incidental and arbitrary you can identify ideas
you want to pursue by marking them with colors.
Targets then become visible.

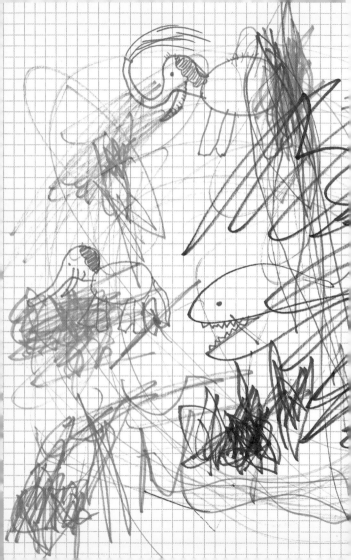

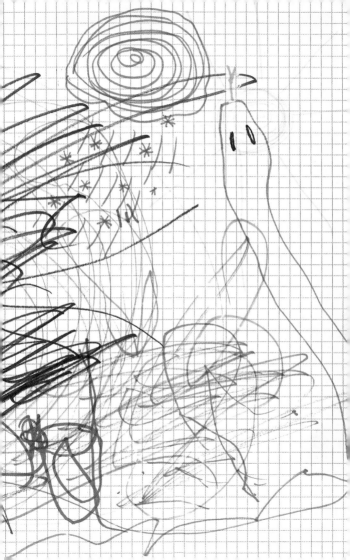

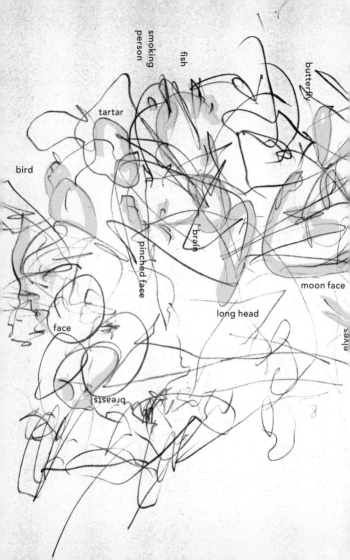

smoking
person

fish

butterfly

tartar

bird

brain

pinched face

moon face

long head

face

elves

breasts

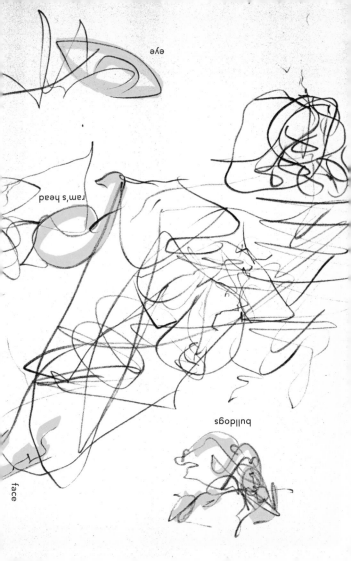

eye

ram's head

bulldogs

face

13

Shadows

Shadows are more complex than the black or dark-gray blobs they may appear as at first glance. Gradations of tones, nuances, and hints of color are all characteristics of shadows.

Expanding you field of vision
Photograph images of shadows (in color) and document the transition from light to dark, paying close attention to subtle changes.
At first just gather general impressions, then try to look for forms.

with
a crown

witch's
house

Where's
the
rabbit?

man with
a big belly
with his
arms crossed
behind
his back

card
game

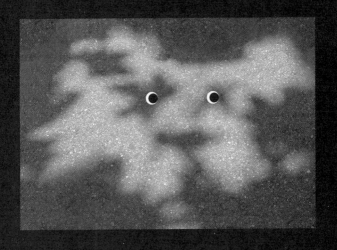

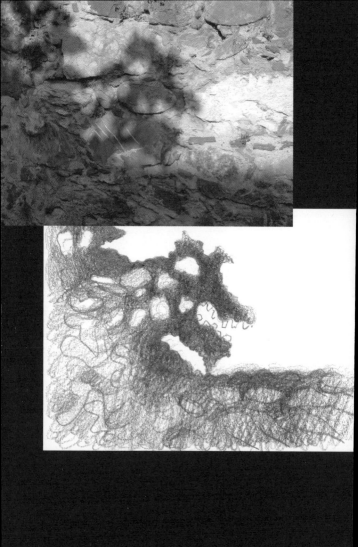

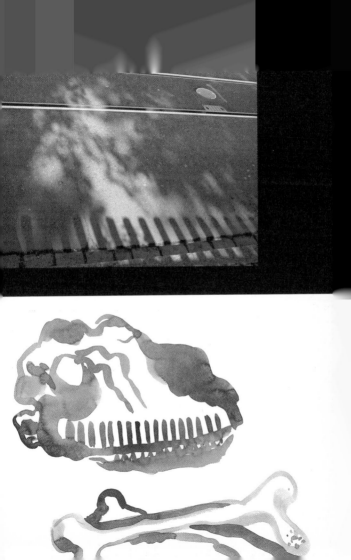

14

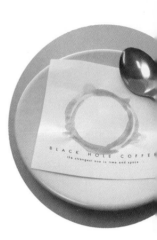

Coffee stain

Stained tablecloths or neckties that accidentally dip into coffee are rarely seen as objects of beauty, even though the soft tones of the stains are visually appealing in their own way.

Expanding your field of vision
The goal here is not to prevent stains but to look for exceptional shapes within them. By turning and positioning the stained object, you will be able to create a wider range of shapes. Using different tools (cup, spoon) to create stains will also enlarge the number of motifs.

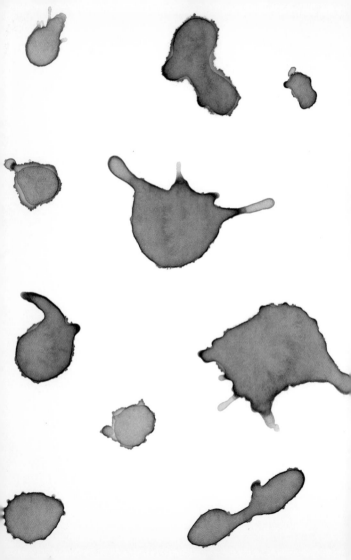

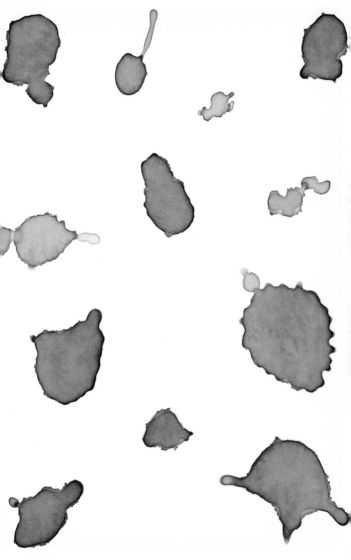

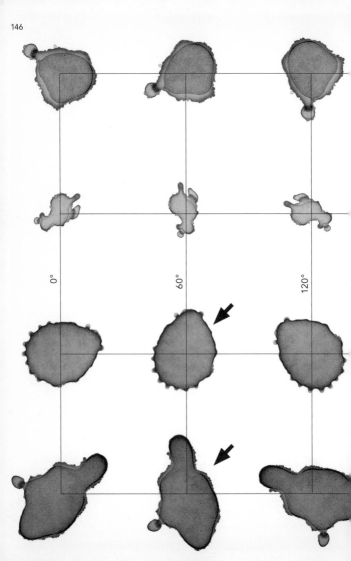

0°

60°

120°

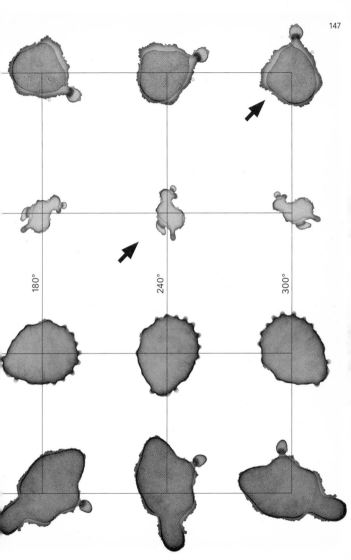

180°

240°

300°

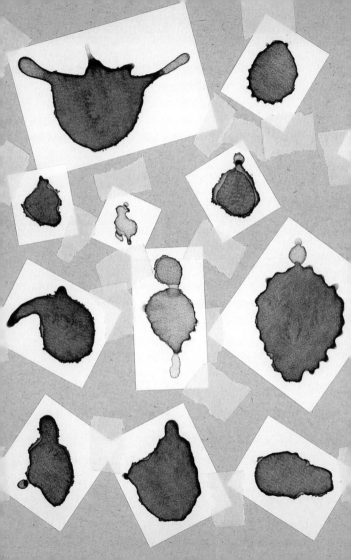

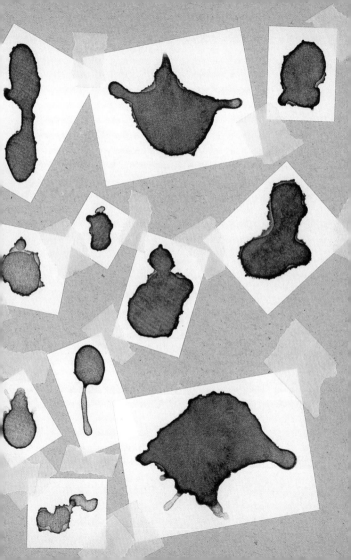

15

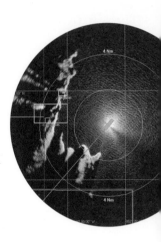

Obscuring

Blurring, inverting the contrast, and using a low-resolution version of a photograph increase the number of possible interpretations of an image. Shrouded in ambiguity, shapes are momentarily identifiable. The media that can be manipulated and made indeterminate are not limited to photographs—this technique can also be used with watercolors, for example.

Expanding your field of vision
Copy a black-and-white photograph onto black (or nearly black) paper. With a light-colored pencil, rework the original image and look for new shapes that will appear.

156

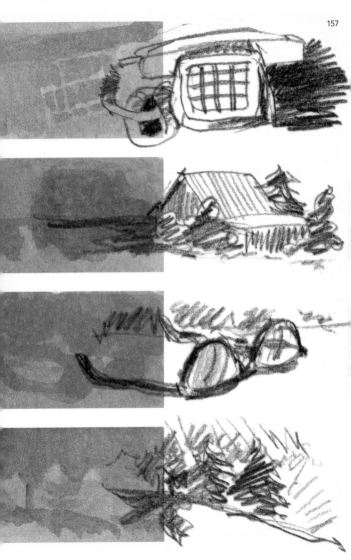

16

Cutout

Squinting or blinking; looking through a
telescope, a camera, a window; or using the
horizon as a reference point—all of these actions
are opportunities to engage with the limitless
wealth of the visible world.

Expanding your field of vision
Concentrate on details of various objects to limit
what is visible to only a part of the whole.
It doesn't matter whether you use sheets of
paper as brackets or any other type of frame to
look through. What is important is that the
familiar becomes unfamiliar.

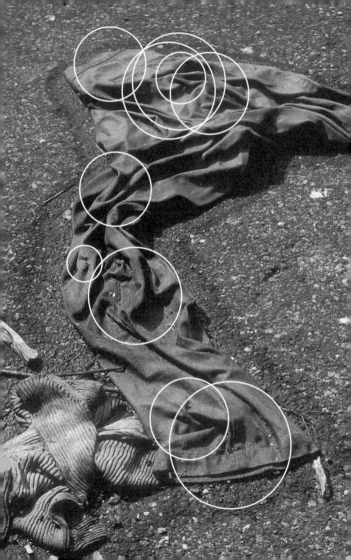

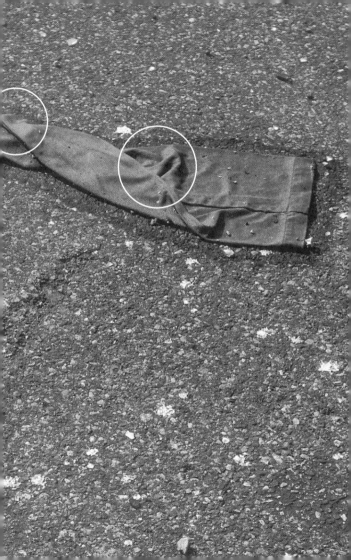

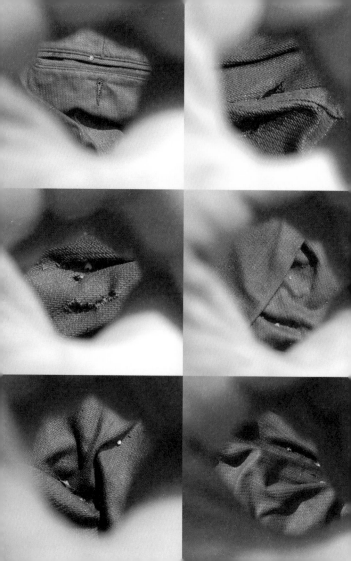

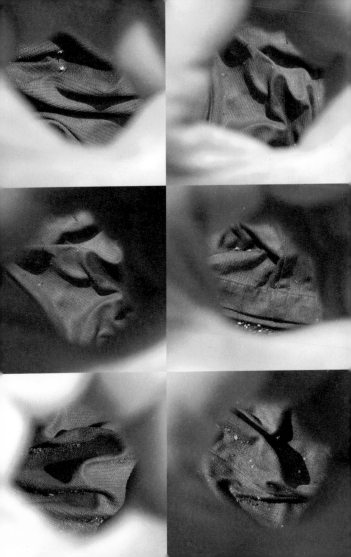

17

Wood

The knots of a tree trunk reveal various shapes and patterns when viewed in section, and the grain of the wood adds even more texture.

Expanding your field of vision
Take photographs of the wood grain of boards, furniture, walls, etc. Create your own inventory of wood pictures. You can employ them simply as tools of investigation or use them as inspiration for making discoveries in drawings.

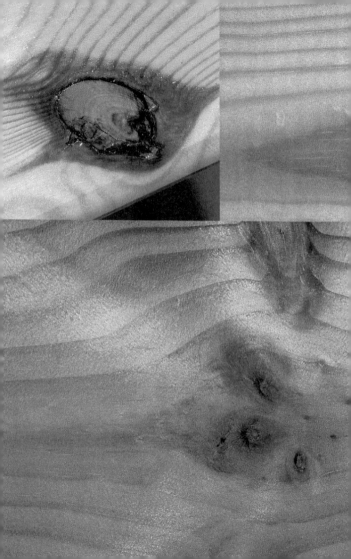

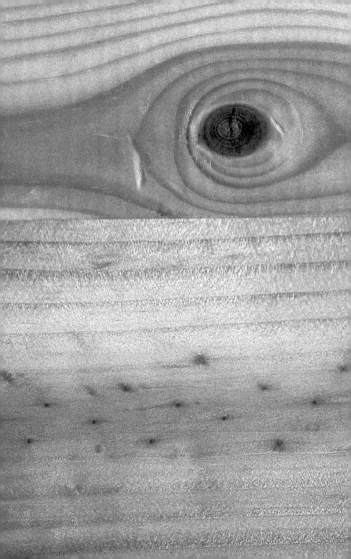

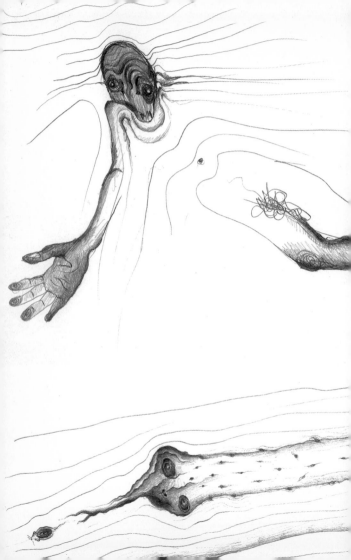

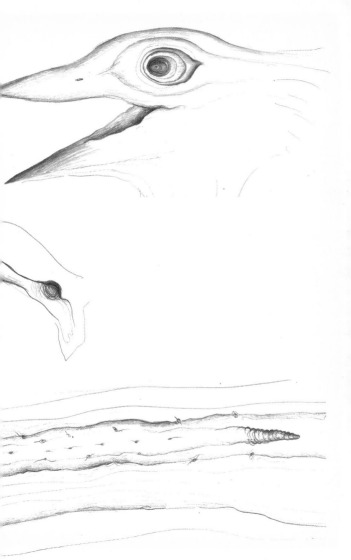

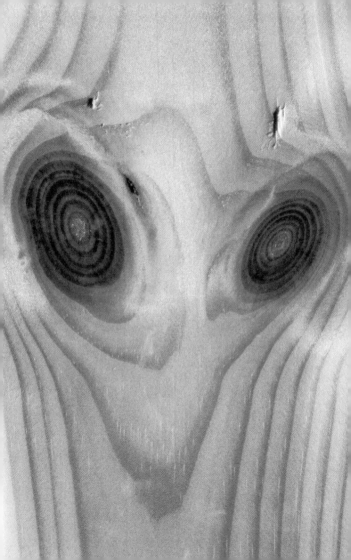

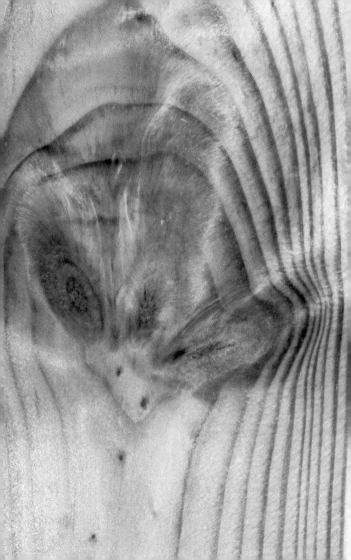

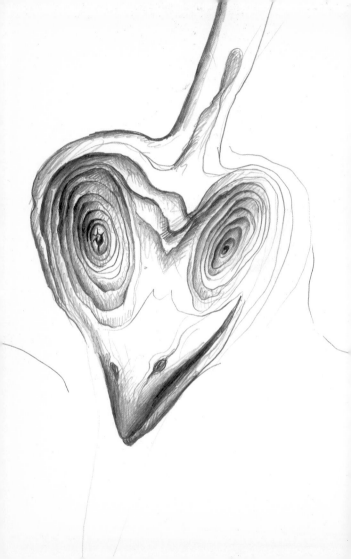

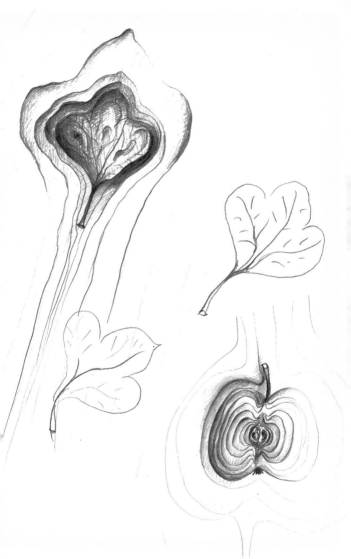

18

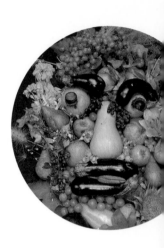

Face

Our eyes, constantly in search of forms, find images wherever they want to see them. The face is commonly sought out, because of its familiarity to us. (That's why it is a subject of exercises in several of the chapters.)

Expanding your field of vision

Look everywhere for facial elements—a set of eyes and mouth. If you are actively looking, you will see faces in the most unexpected of places, each speaking to you in its own way.

178

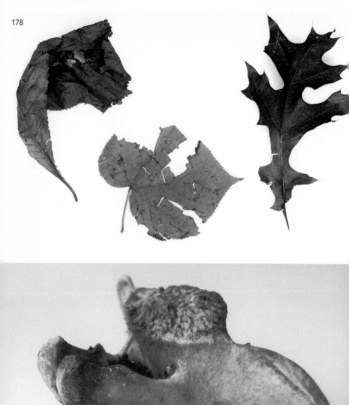

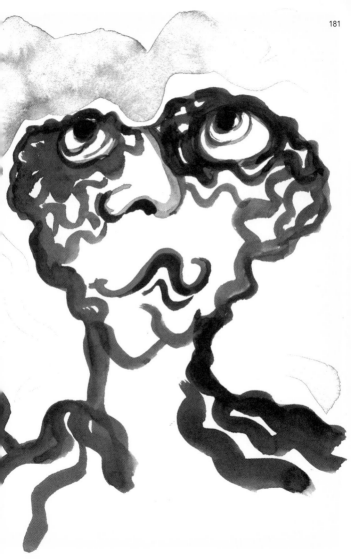

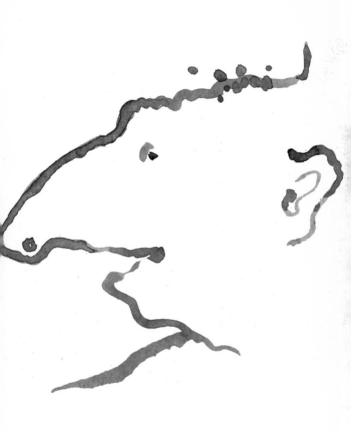

19

Typeface

In the age of the computer writing something
by hand has become increasingly rare.
Handwriting is so individual and personal that
it is an image itself.

Expanding you field of vision
Compose a text. Choose a section of it without
regard to orientation or the meaning and logic of
the text. (It doesn't matter whether the words
are right side up or upside down.) Experiment
with different writing tools: soft, hard, thick, thin.
If you enlarge them on a photocopier, it will be
easier to search for shapes in the text fragments.

Wetter al

bis Sam

Woch un

veränder

nicht me

aber schw

holt Reg

Gewitter

...chten

tag = Mitt-

Donnerstag

...a und

...r so heiss,

Wieder-

...schauen/oder

Dazwischen

person wearing glasses

 child giving his hand to his father

man squatting

pug nose

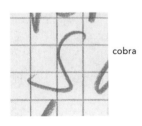

cobra

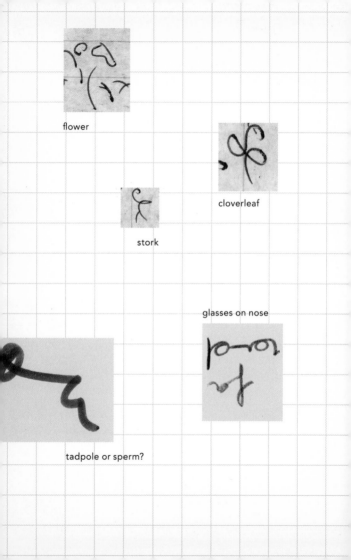

flower

cloverleaf

stork

glasses on nose

tadpole or sperm?

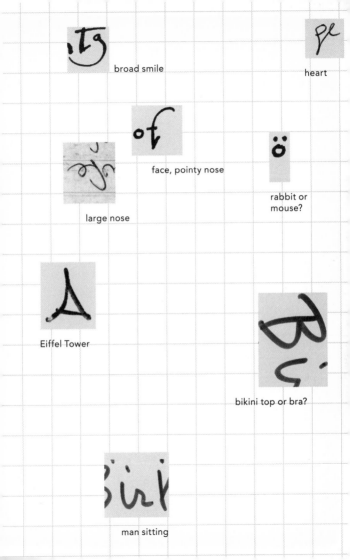

broad smile

heart

face, pointy nose

rabbit or mouse?

large nose

Eiffel Tower

bikini top or bra?

man sitting

20

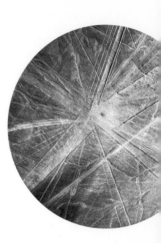

Palm lines

The lines on our palms are incredibly familiar to us. Despite this intimacy no one could draw those lines from memory—you would have to reference the hand.

Expanding your field of vision
Draw your palm lines at actual size. Copy these lines in random combinations—overlapping each other, juxtaposed to one another, all mixed up (copy the same drawing several times over). Enlarge individual stages and forms to see the lines in a different scale.

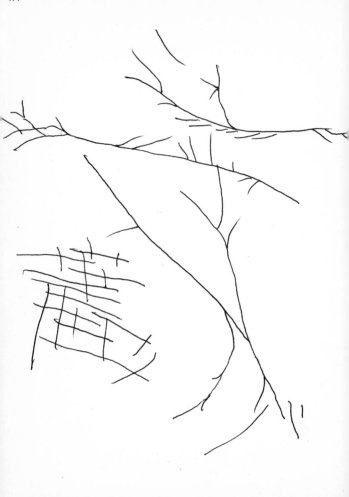

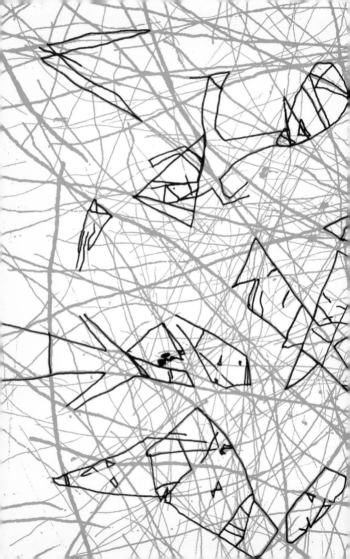

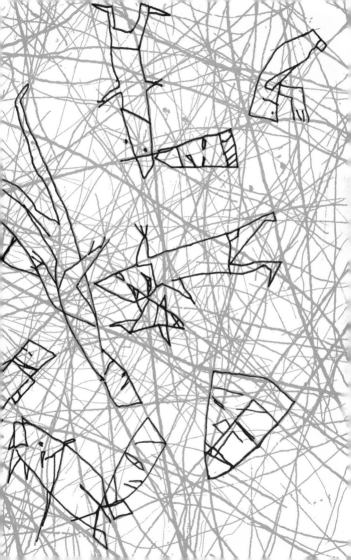

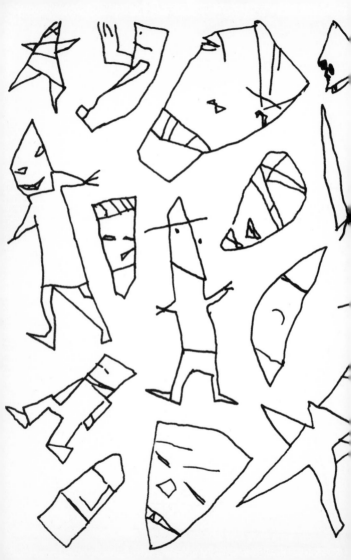

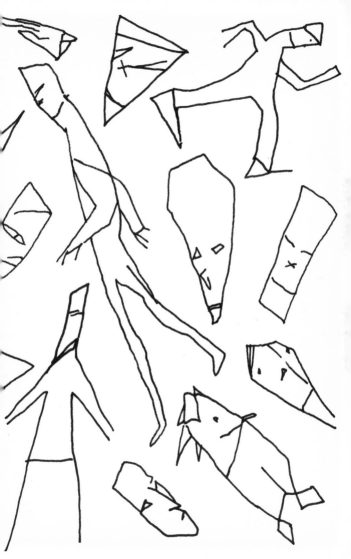

21

Vestige

As anything disintegrates and disappears,
the only remaining parts of it are the vestiges
and traces of it. But when these marks are
used to create drawings, they can become the
foundation of something completely different.

Expanding your field of vision
Find a trace and think up an image or a story
that is associated with this trace.

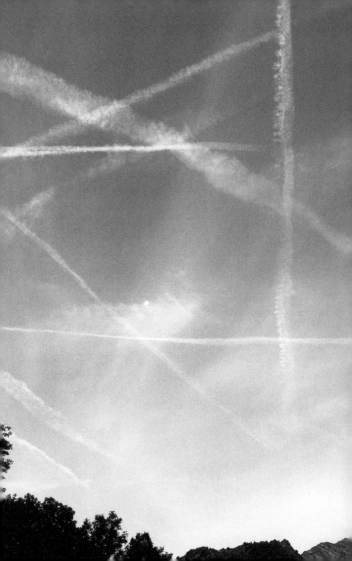

It is only when wanderlust has already set in, when you are frustrated with work, and when getting up in the morning is torture that you can easily imagine sitting in a plane, sipping a glass of prosecco, and being served from the little cart as it passes by—dreaming alongside the vapor trail of a passenger plane, the very vapor trail that is leaving behind white railroad tracks in the sky...

22

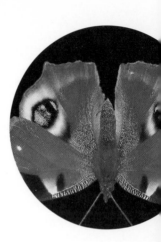

Eyes

Creating a whole out of various distinct objects requires you to use elements that the viewer will join together.

Expanding your field of vision

Brackets and round forms that relate to each other join together in our perception into a whole. A pair of eyes, in particular, is easily recognizable as a whole. A page with eyes that you can use as a copy template is found on the following spread.

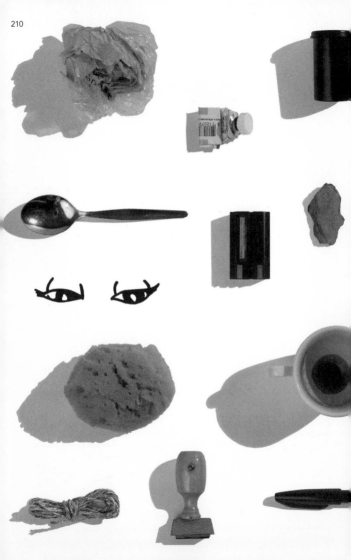

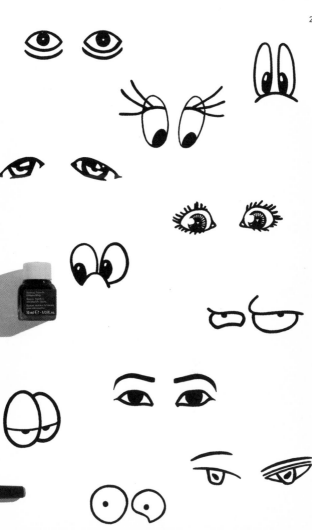

214

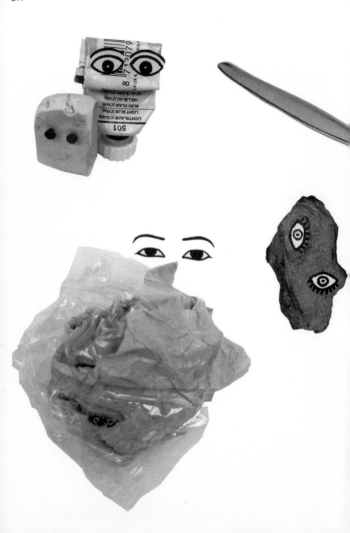